How to Draw
Farm Animals

In Simple Steps

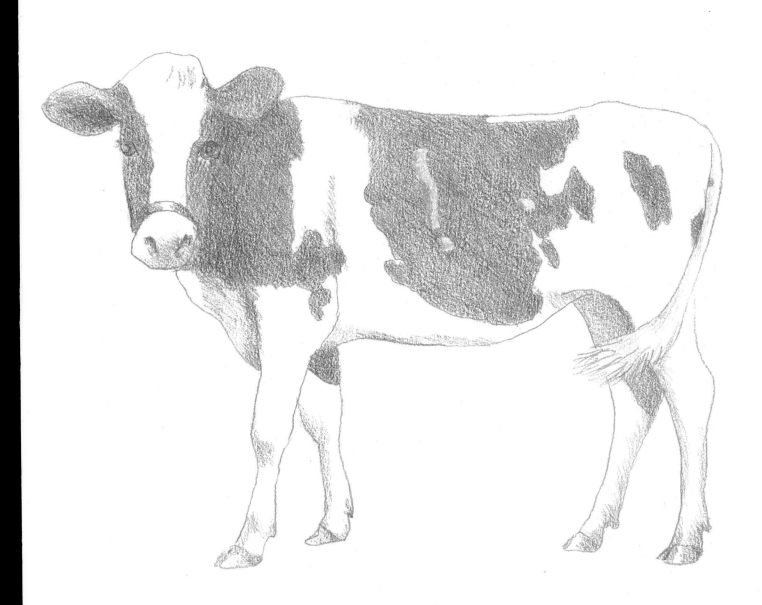

First published in Great Britain 2018

Search Press Limited
Wellwood, North Farm Road,
Tunbridge Wells, Kent TN2 3DR

Text and illustrations copyright © Susie Hodge 2018

Design copyright © Search Press Ltd. 2018

ISBN: 978-1-78221-624-7

Printed in Printed in Malaysia by Times Offset (M) Sdn. Bhd.

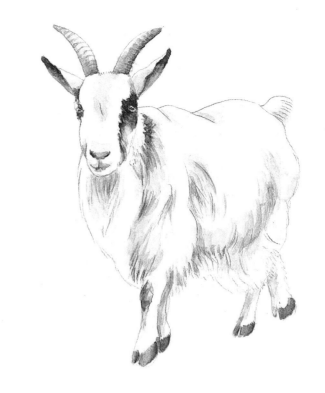

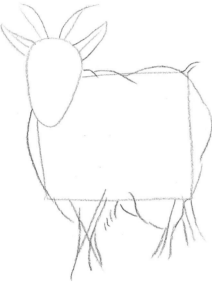

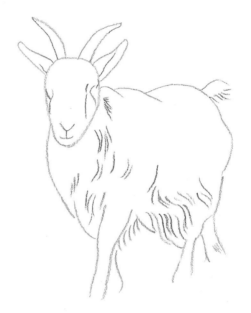

Illustrations

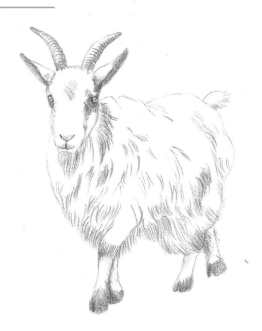

How to Draw

Farm Animals

In Simple Steps

Susie Hodge

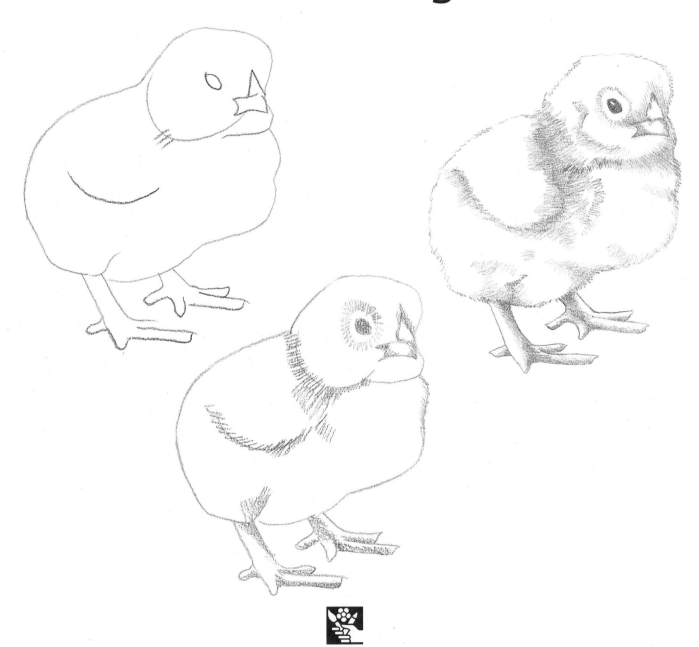

Search Press

Introduction

Welcome to a book full of farm animals! There are large and small animals; some cute, some ugly; some familiar and some less well-known. All are shown, beginning with the most basic shapes that then, through five simple steps, become finished, detailed drawings.

The aim of the book is to demystify the drawing process and to show that everything we see can be drawn using simple lines and shapes. Whatever the animal, the process of building it up from the most basic forms into a finished, detailed drawing is the same. When any image is broken down like this the process of drawing becomes more straightforward, and you will see that drawing animals – from capturing their basic outlines to introducing detailed tones and textures – is probably far easier than you thought.

In this book, I have used two colours for the step-by-step process to help you see which lines are added at each stage, but there is no need for you to do the same – a pencil is probably easier. Choose a fairly soft one such as a B or 2B, keep it sharp and don't press too hard, as this makes it easier to erase any previous guidelines as you go.

In the first stages of the drawings, the basic outlines of each animal are in blue. In the next stage, those first lines become brown and all new lines, in blue, build up a more natural animal shape. Next, details start to be marked on such as ears, legs and some early tonal marks. Finally, facial features, textures including fur and shiny noses and eyes, and any remaining shading, are added. You don't need to draw every hair or whisker for this – use a light touch and include only general indications, such as some of the fur and the darkest tones. The final image on each page is the same animal in watercolour, to show you another option of how to finish your drawing. Use whatever materials you like, but if you are using watercolour keep your water clean and your brushes damp and not too wet.

Before you begin, imagine the look of your animal on the page and consider each stage carefully, keeping in mind proportions and angles – for example, the angle of an ear or the proportion of a hind leg, and the size of the body in comparison. Make sure you have drawn the correct proportions and angles before you move on to the next step.

The simple sequences in this book are intended to make your drawings more accurate and the process less daunting, so please don't worry about sketching perfectly on your first go or making mistakes, as they happen to everyone. Either erase or work through them – don't give up! For this reason I hope you attempt all the animals in the book, as each one will present a different challenge. Once you are used to the process, try drawing some of your own animals from life or from photographs using the same method. If you follow the visual instructions in this book, you will soon feel more confident about your drawing skills and gradually develop your own natural style.

I hope that you will be delighted with your achievements.

Happy drawing!

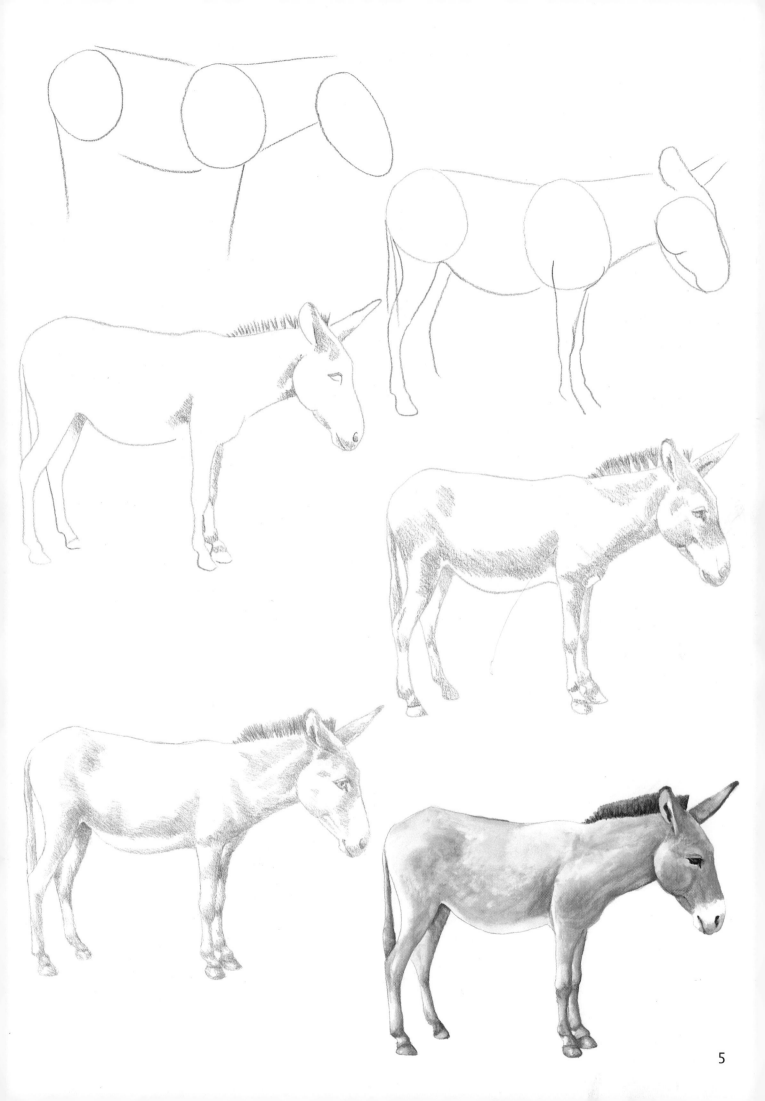

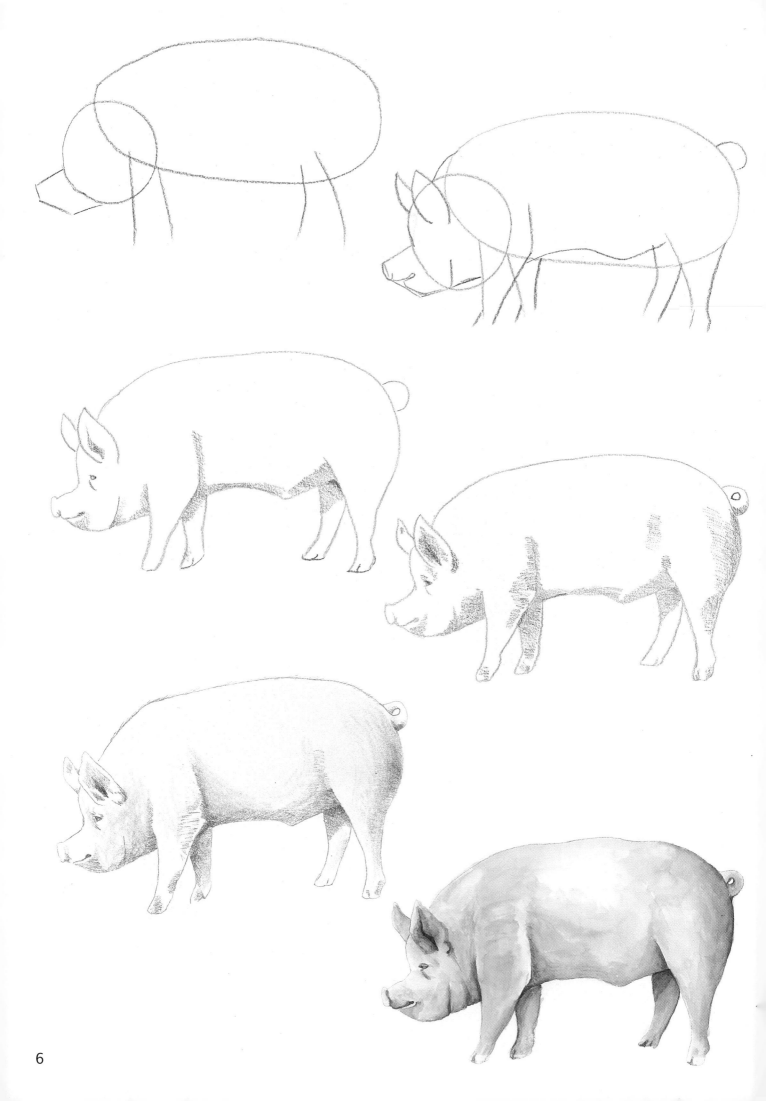

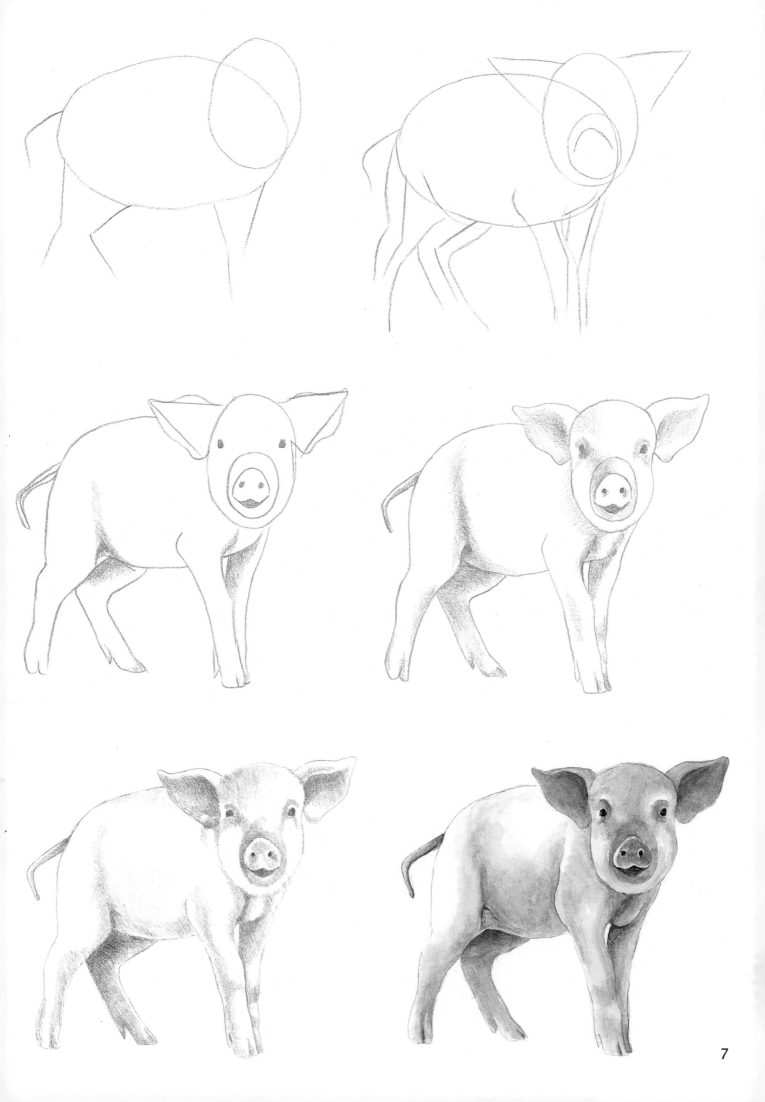

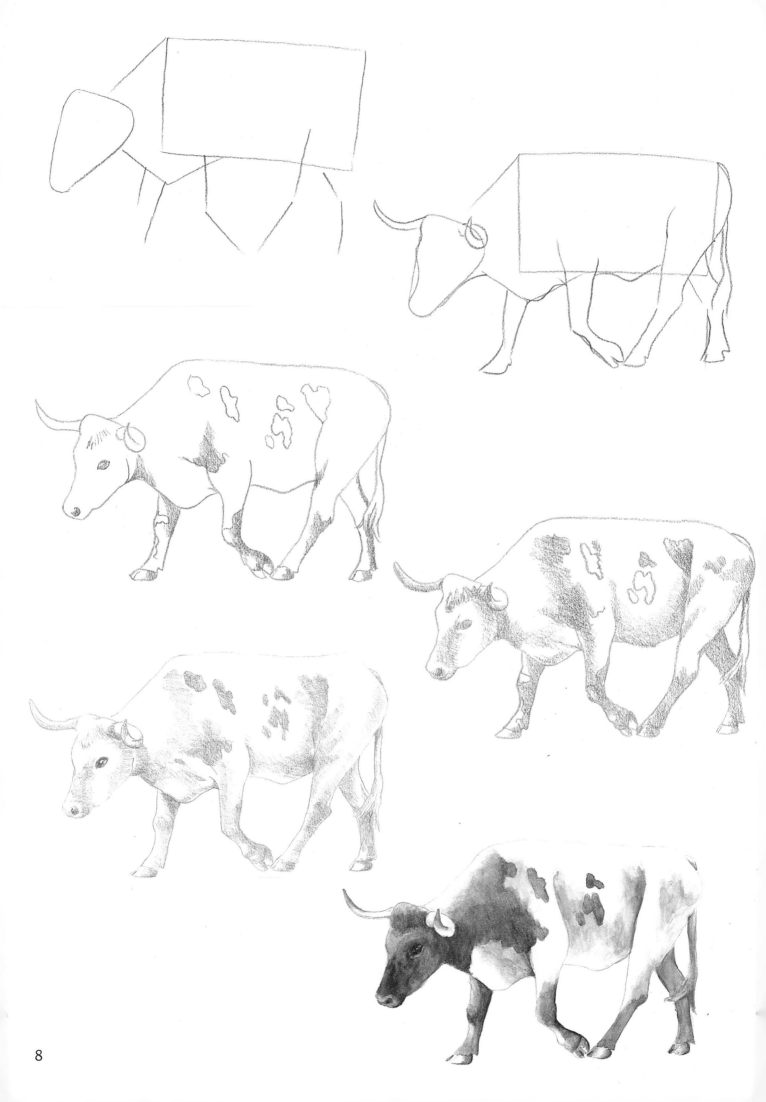

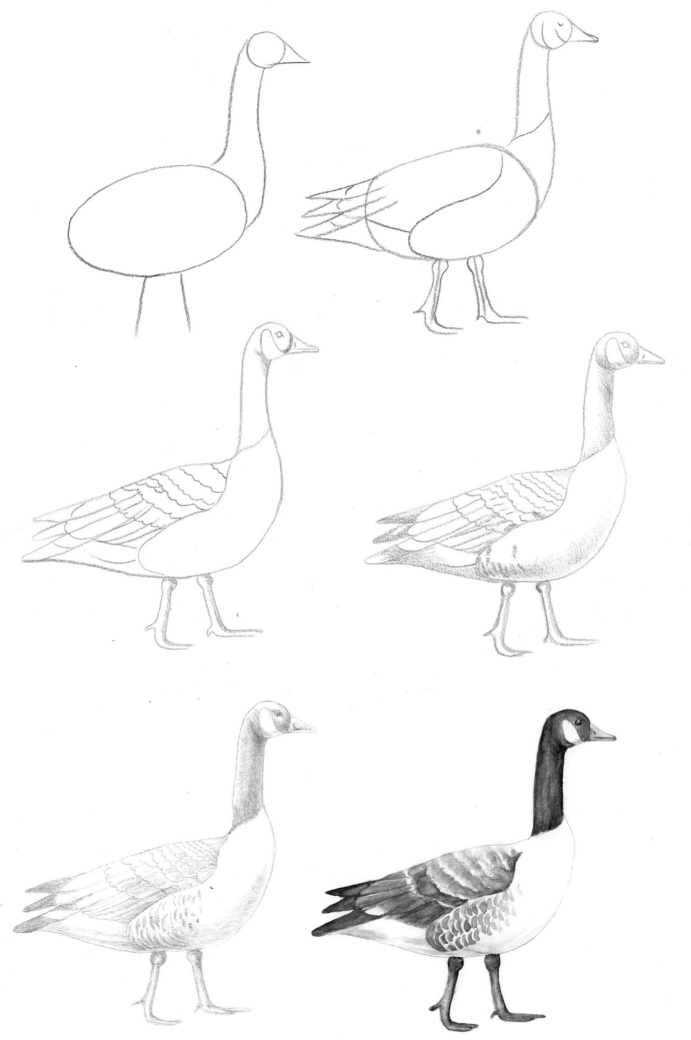

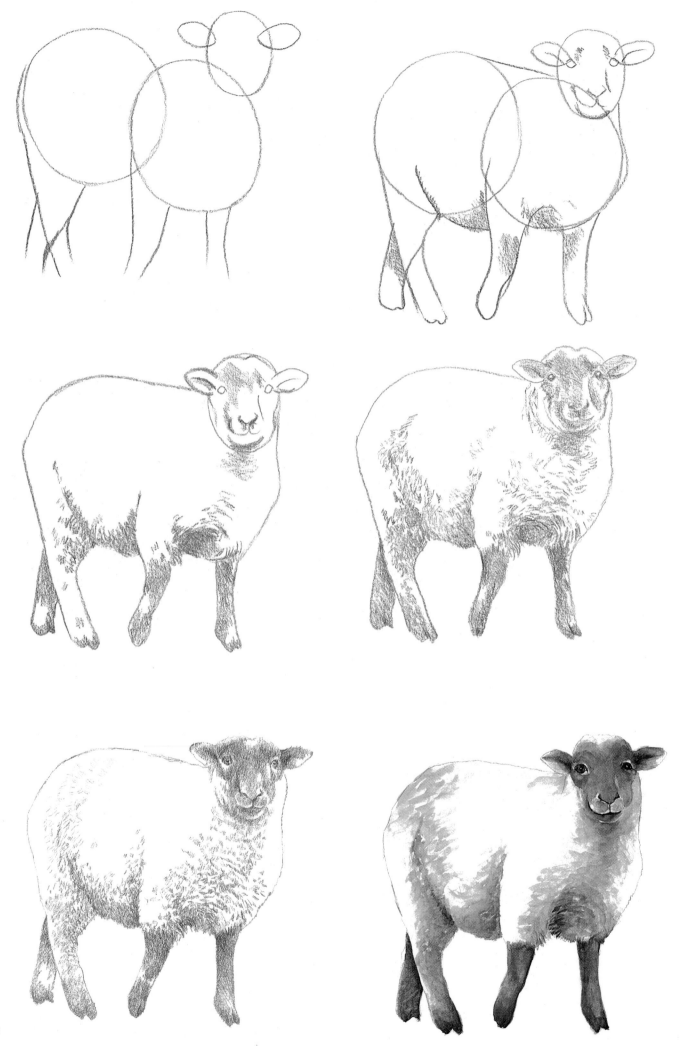

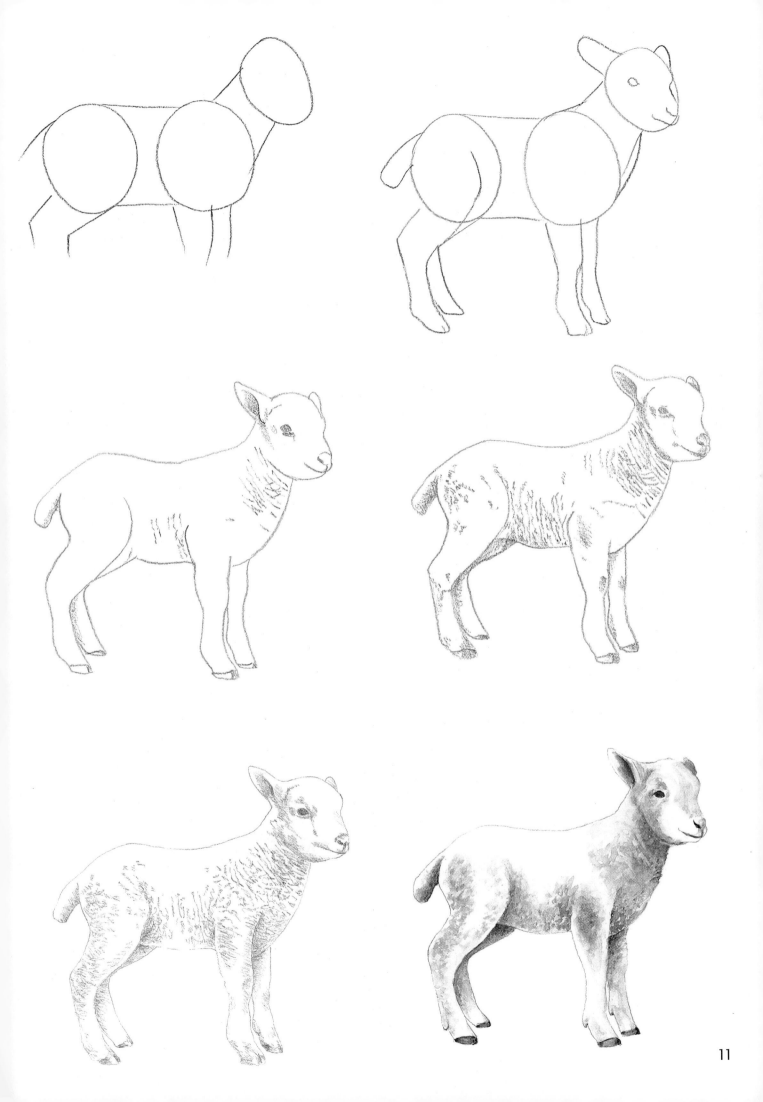

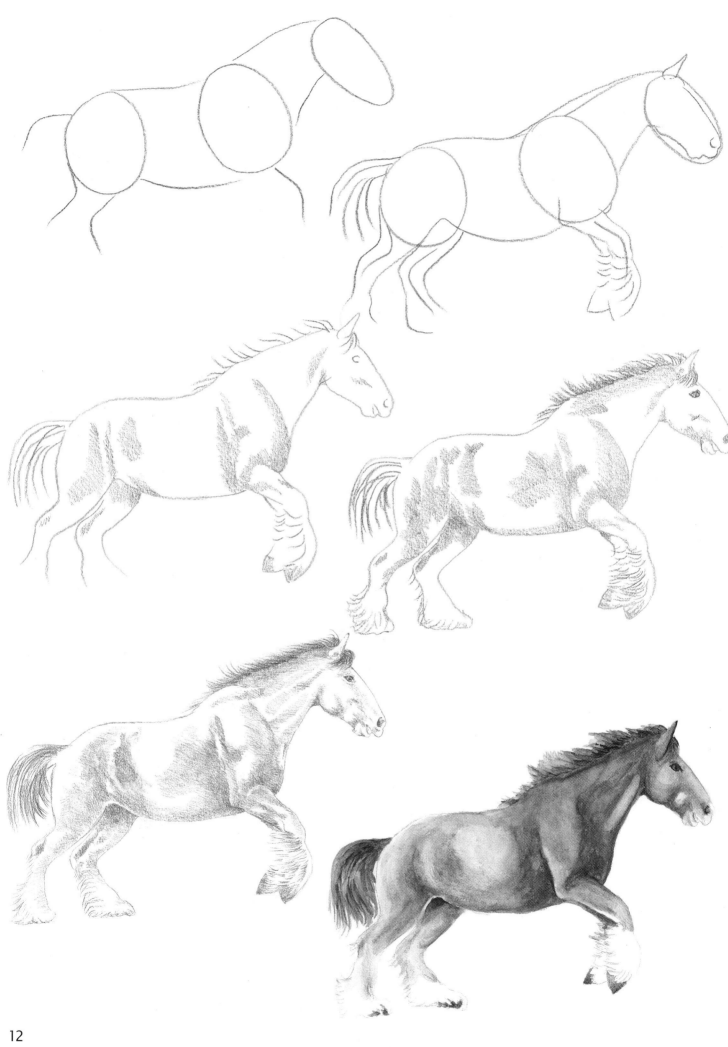

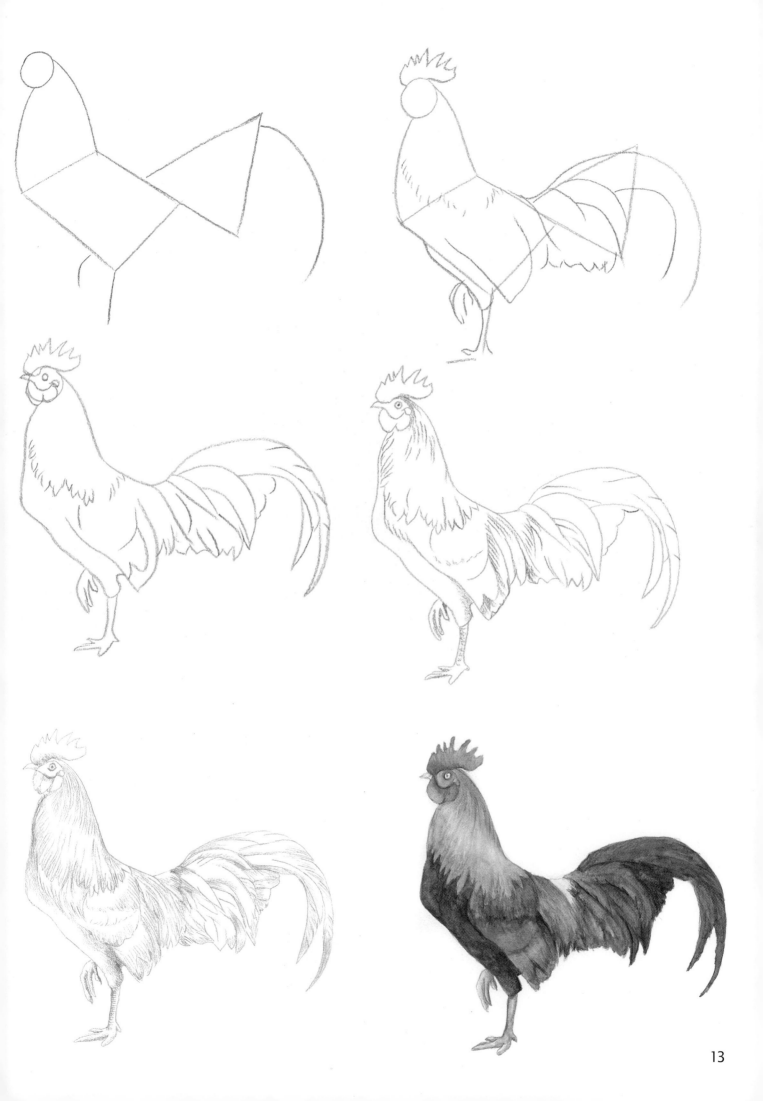

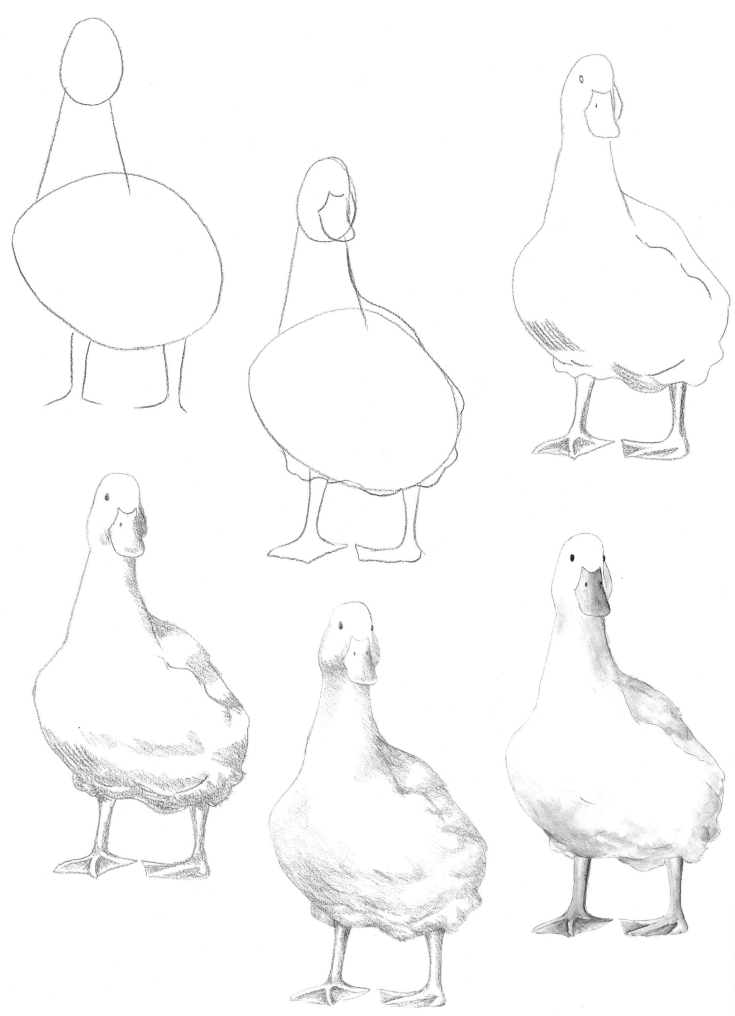

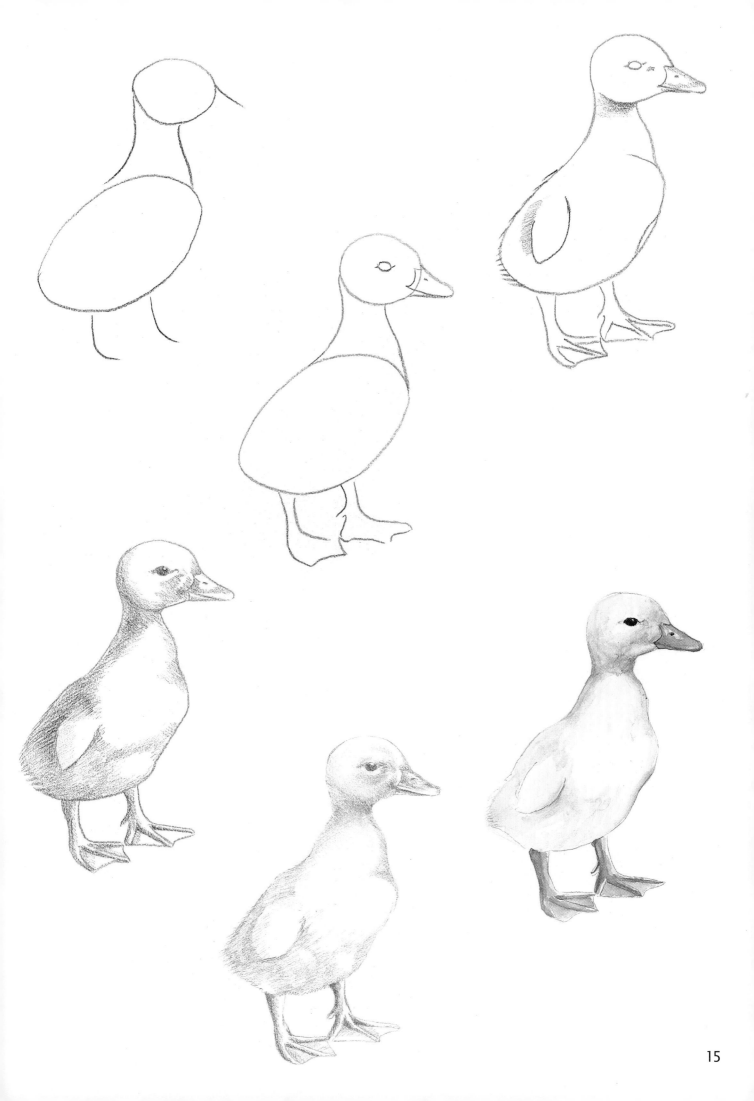

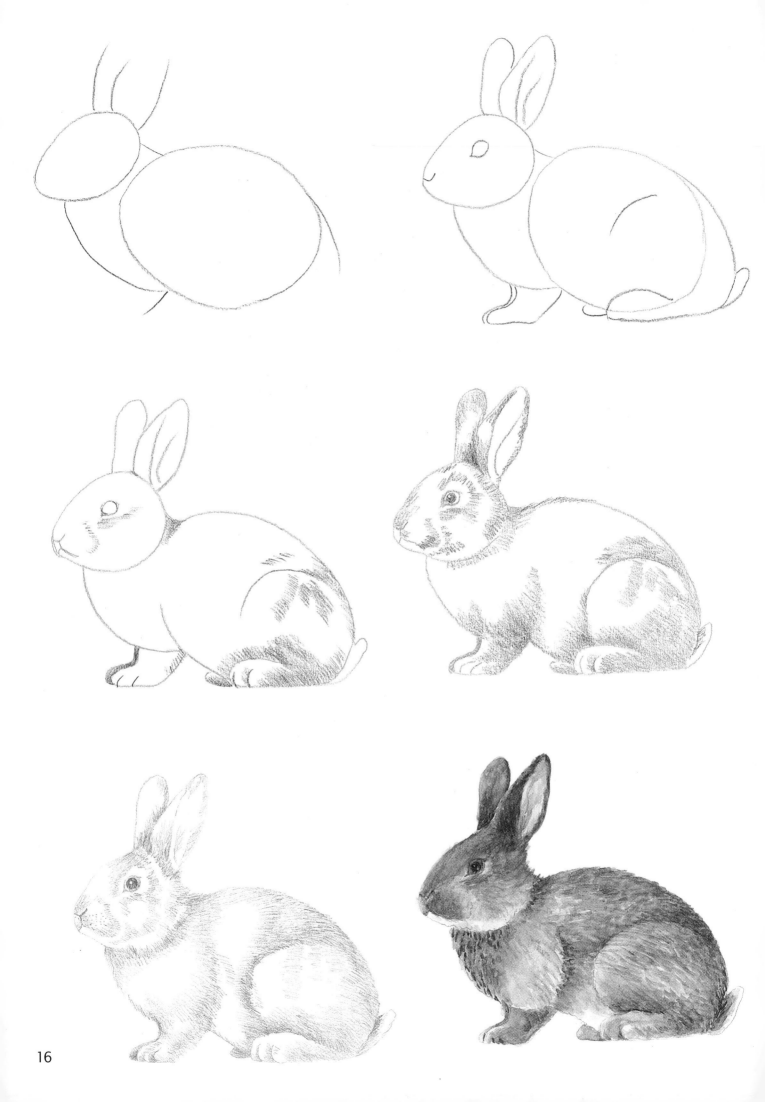

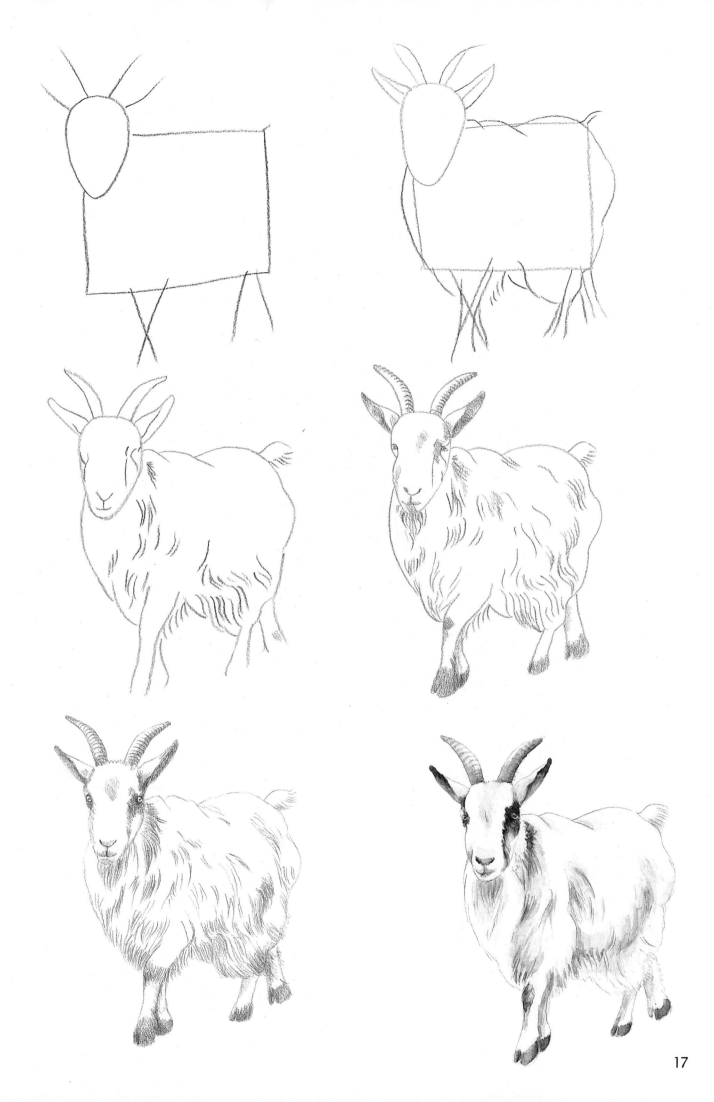

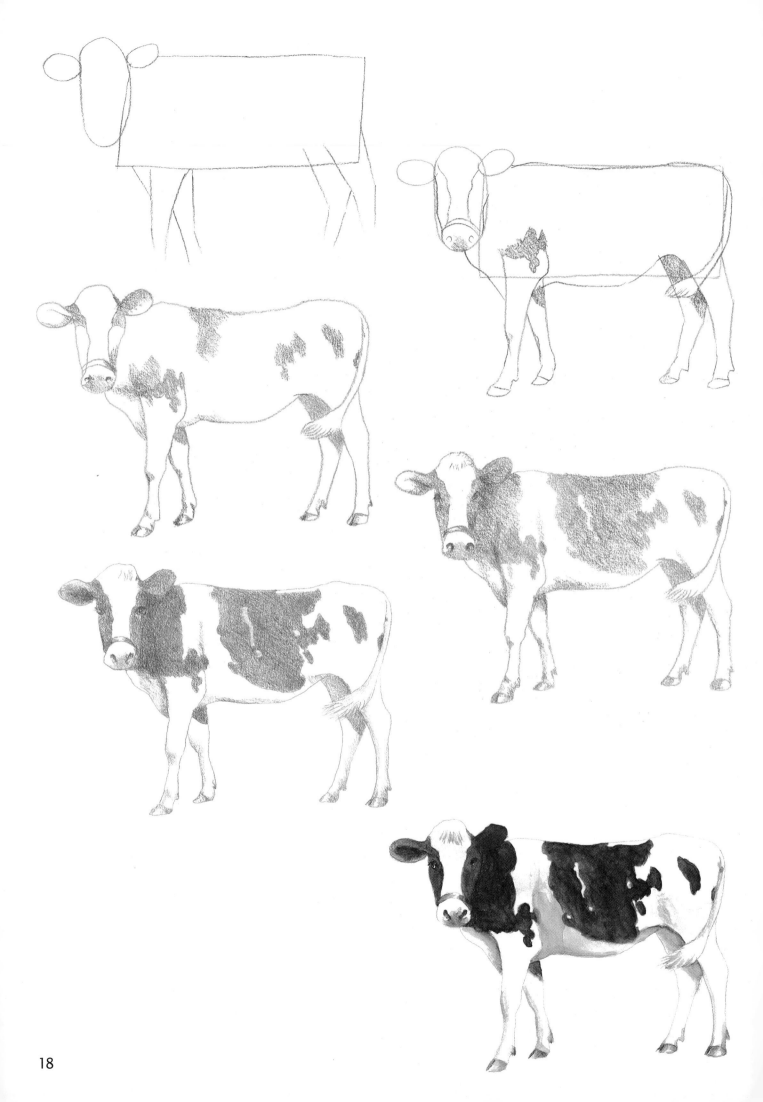

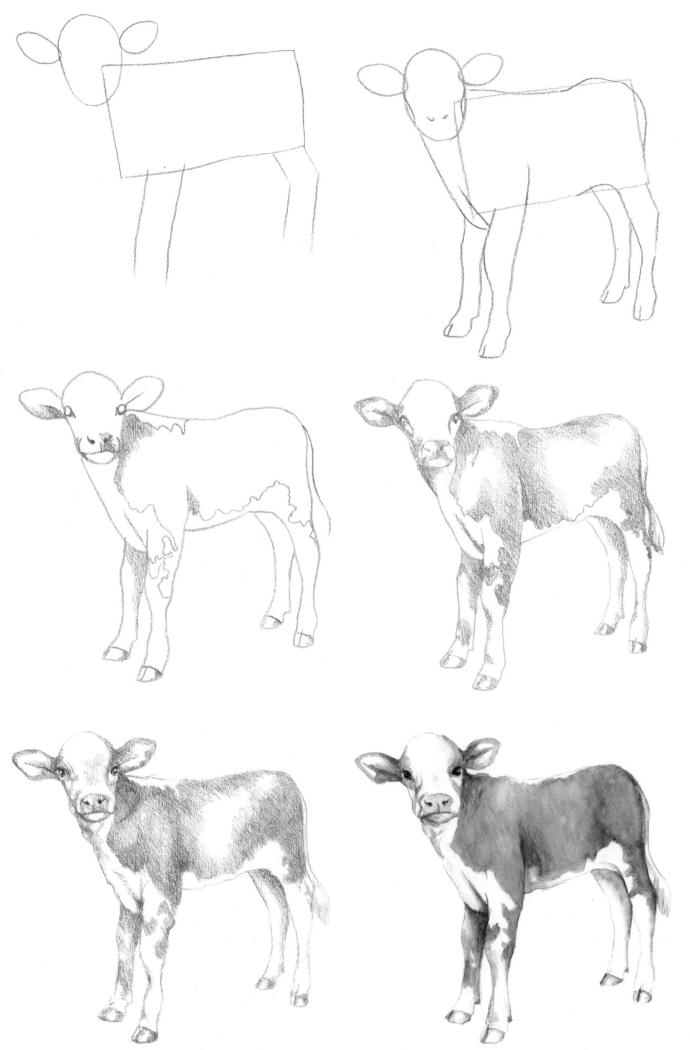

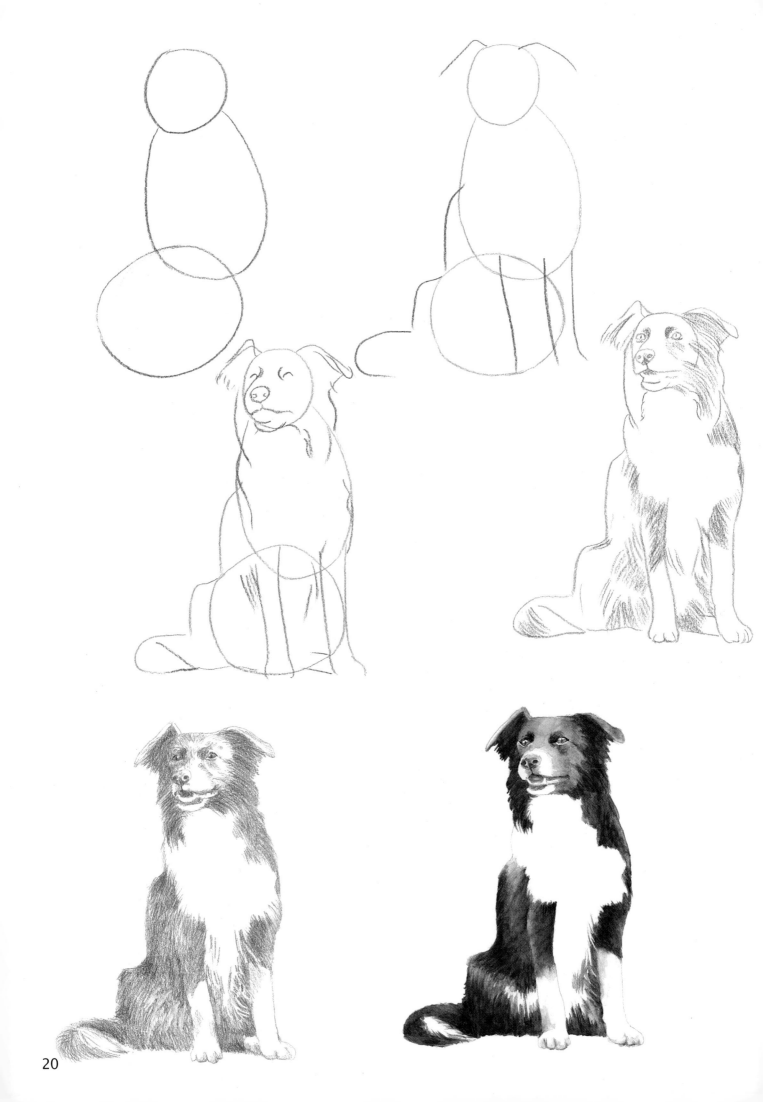

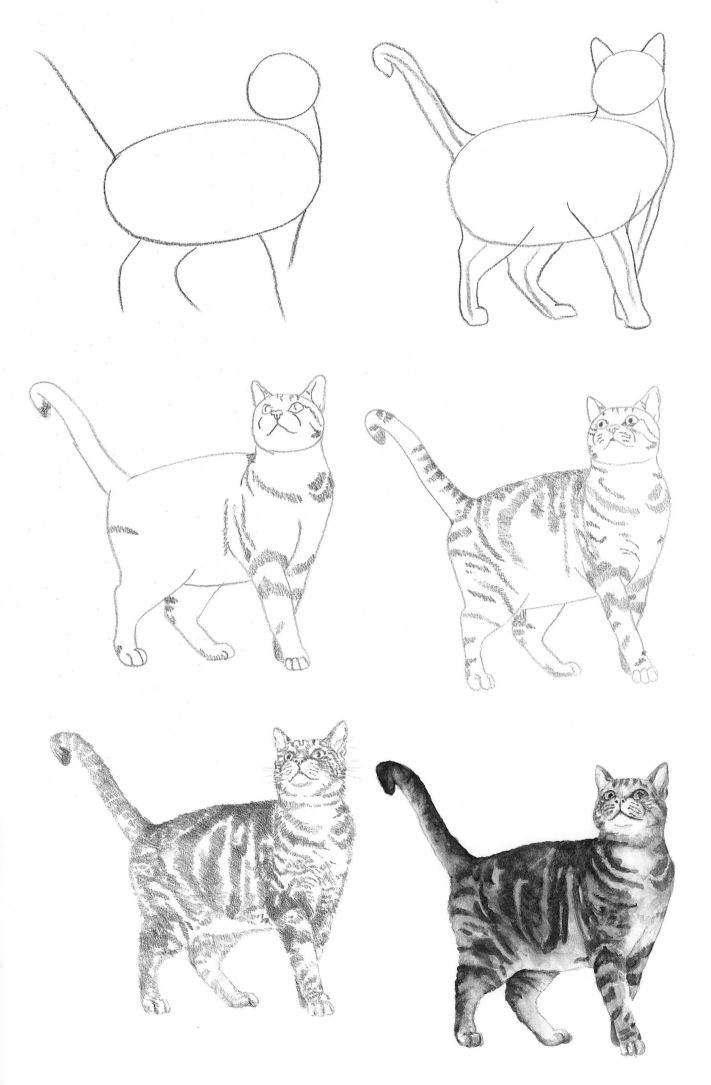

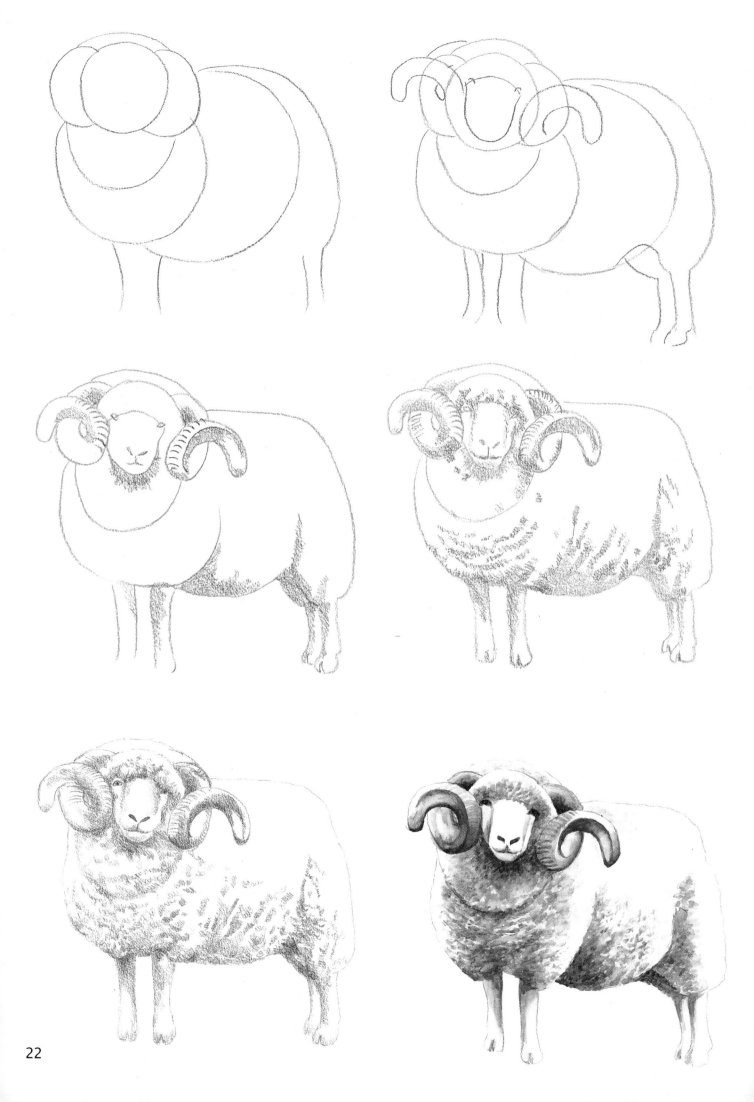

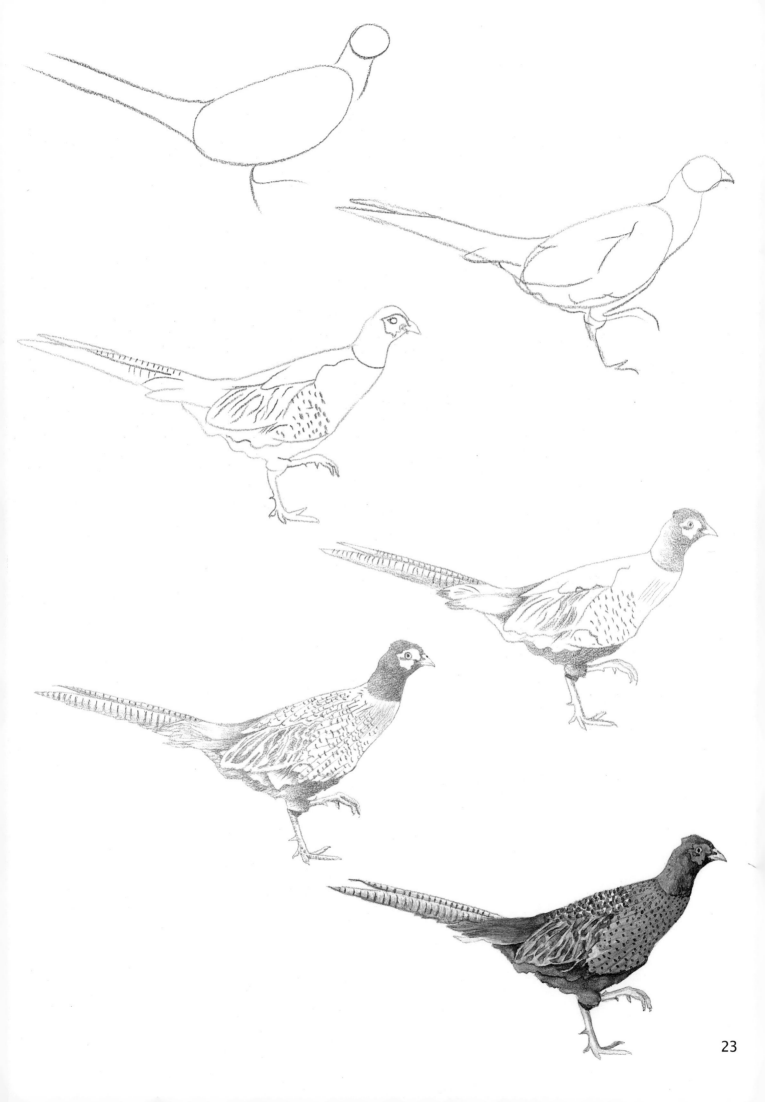

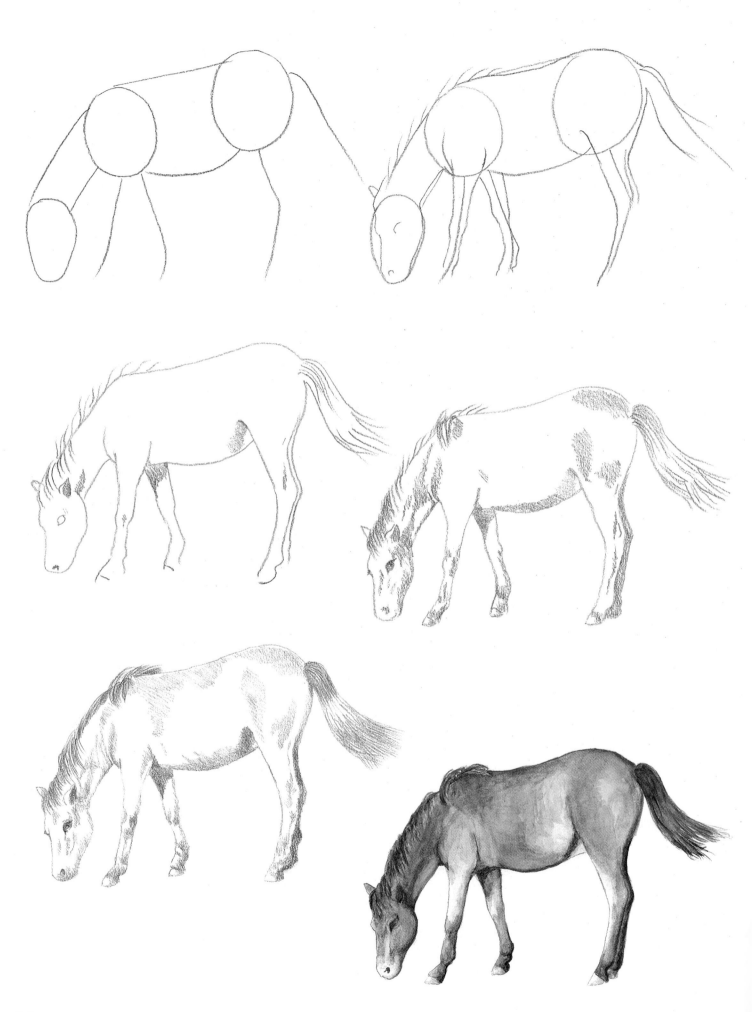

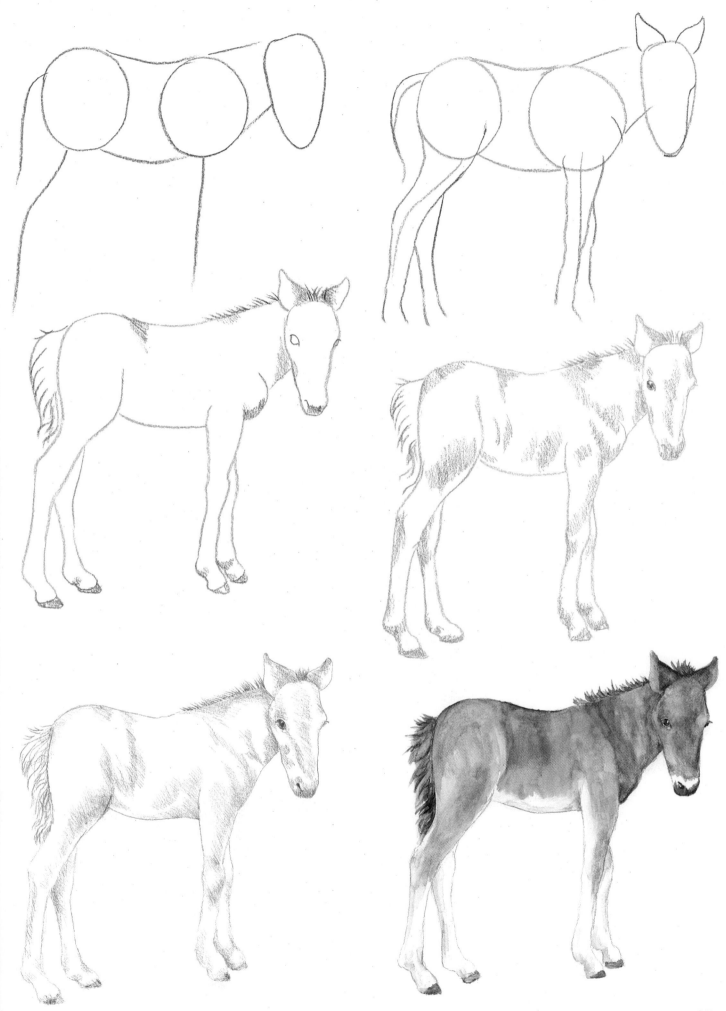

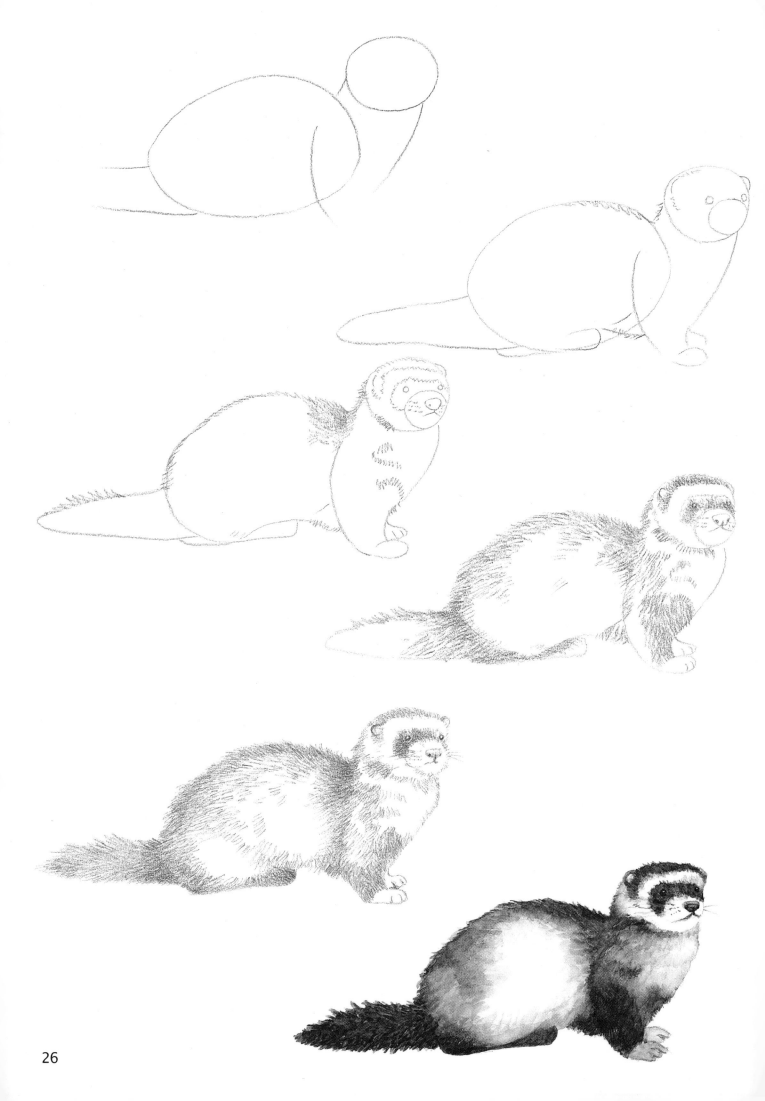

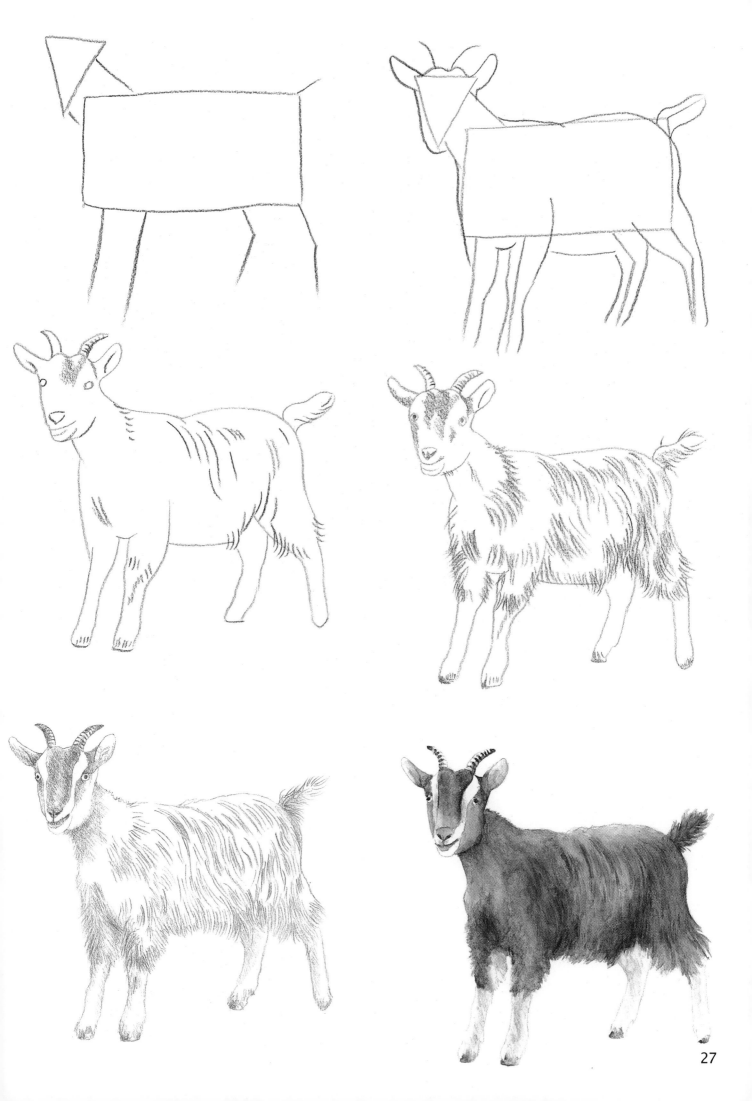

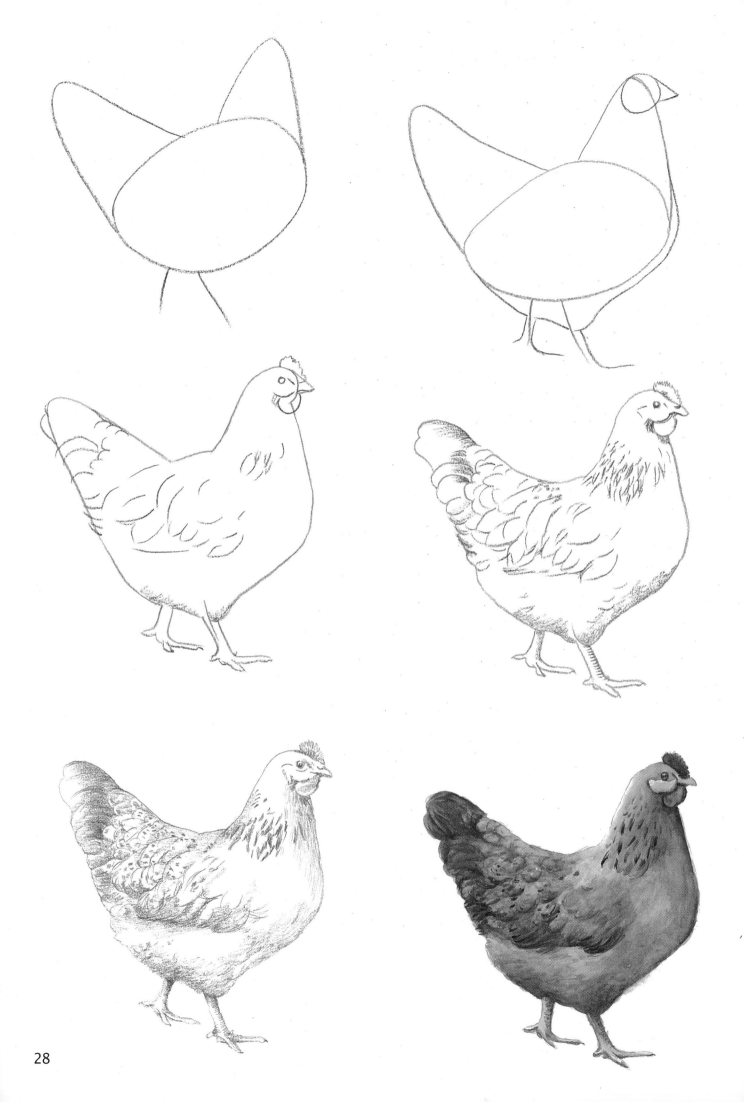

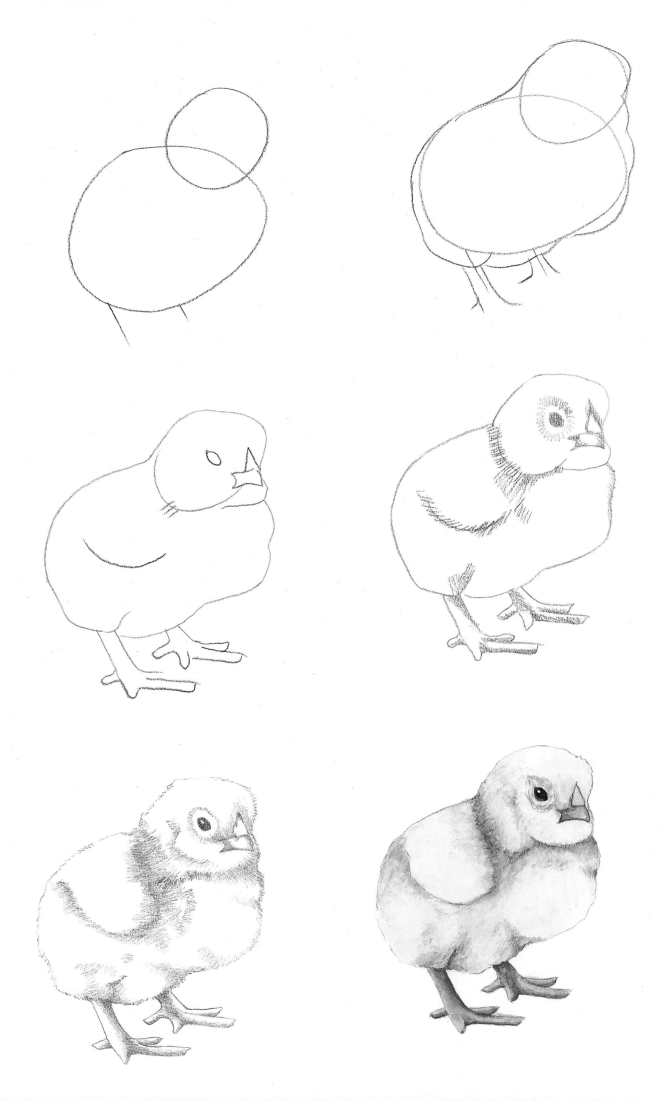

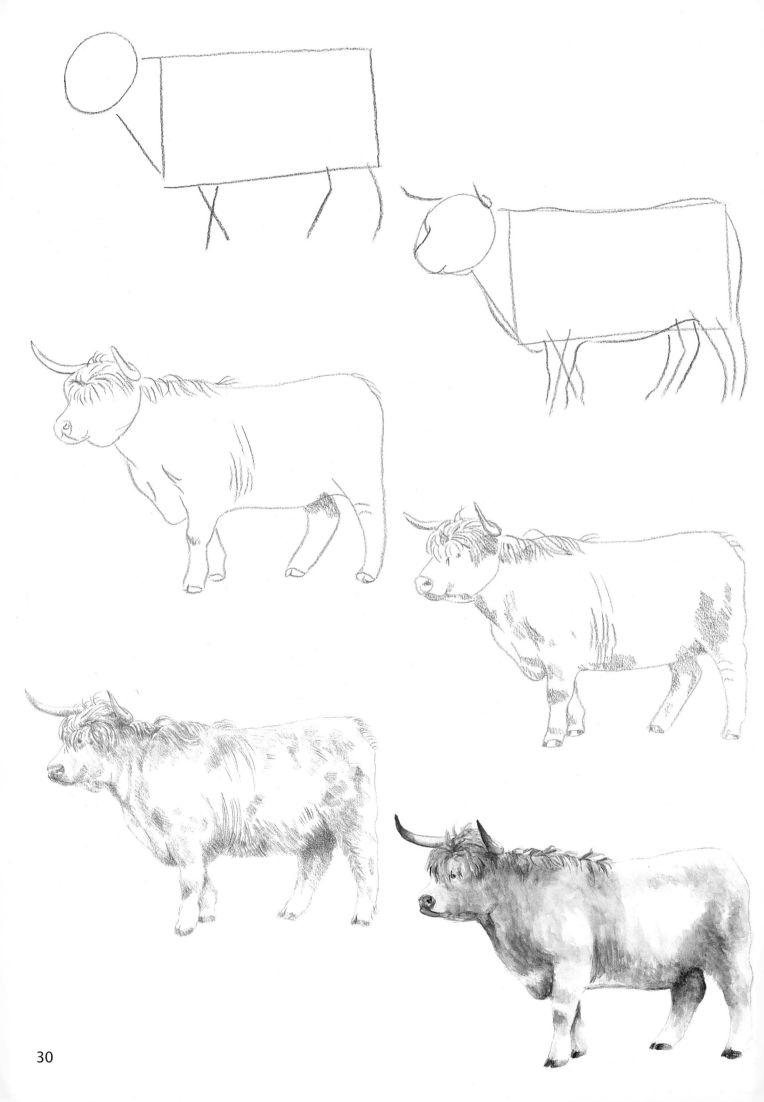

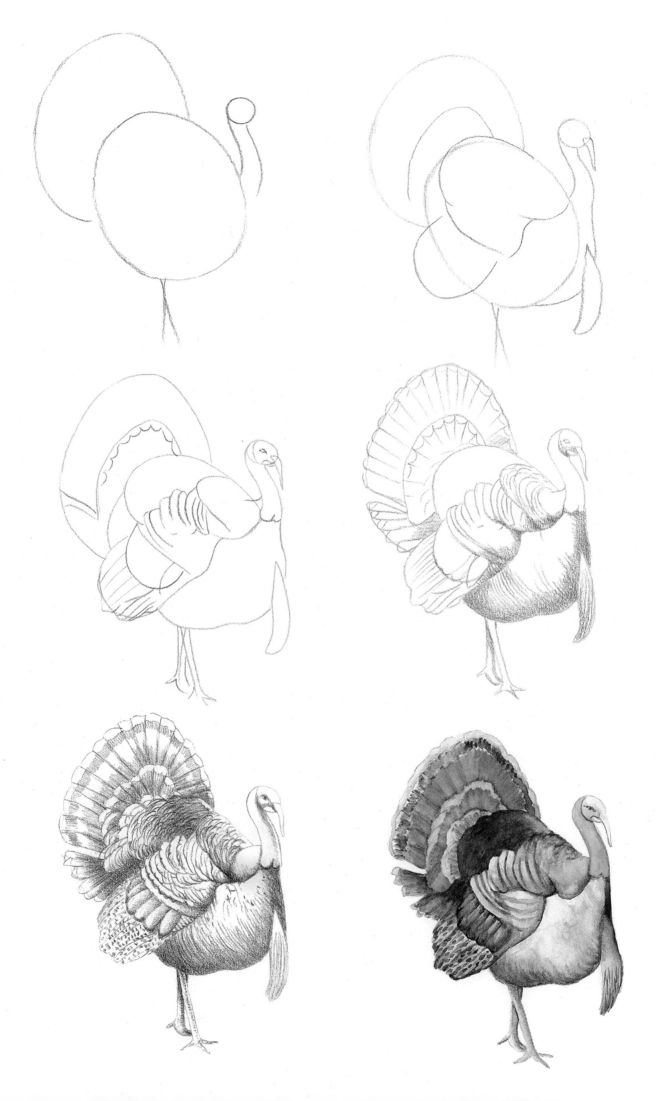

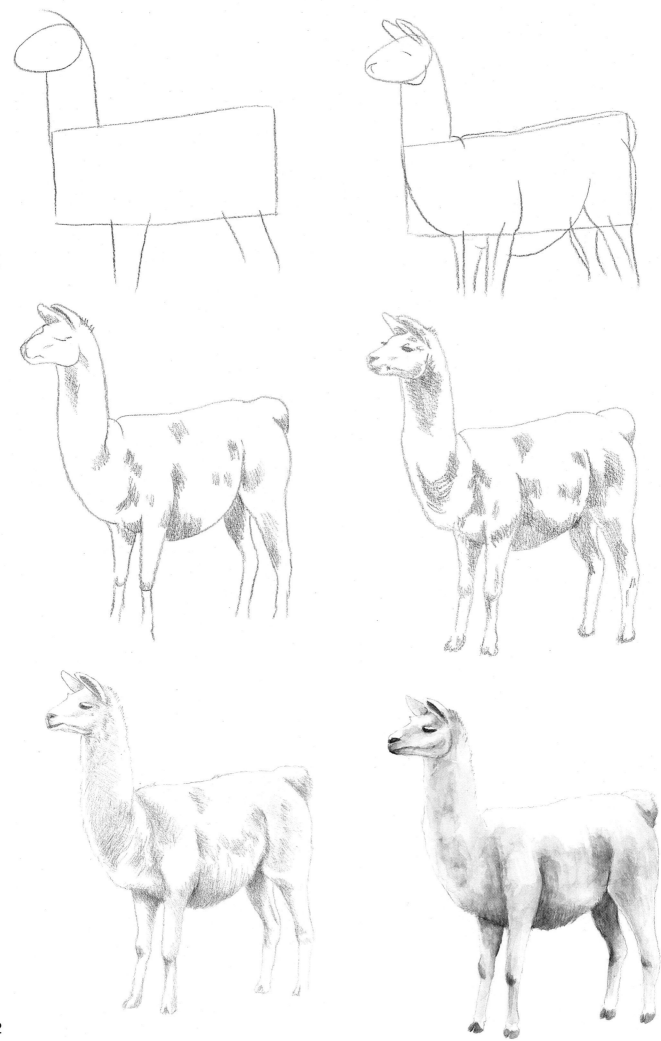